Follow us on social media!

Tag us and use #piccadillyinc in your posts
for a chance to win monthly prizes!

© 2018 Piccadilly (USA) Inc.

This edition published by Piccadilly (USA) Inc.

Piccadilly (USA) Inc.
12702 Via Cortina, Suite 203
Del Mar, CA 92014
USA

10 9 8 7 6 5 4 3 2 1

Printed in China

ISBN-13: 978-1-60863-064-6

Write a poem about
The Ocean

Word
Associations

billows

deep

brine

offing

wave

flux

tide

current

Word Associations

puff

mist

billow

blanket

swarm

thunderhead

nebulous

cumulous

Write a poem about
Clouds

Write a poem about
First Love

tenderness

relish

flame

yearning

cherishing

passion

enchantment

youth

Write a poem about
Spring

budding
flowering
vernal
seedtime
beginnings
fresh
perennial
primrose

Write a poem about
A Tree

Word
Associations

sapling
woods
leaves
greenery
roots
branches
timber
forest

Word Associations

roaring
raging
blustering
tempestuous
squall
blast
gale
wrath

Write a poem about
A Storm

Write a poem about
A Sunny Day

Word
Associations

luminous

summery

shining

clarion

radiant

brilliant

bask

haze

Word Associations

Write a poem about

Anger

acrimony

ire

enmity

indignation

vexation

choler

rage

malice

Write a poem about
Sadness

heartache
bleakness
dysphoria
woe
grief
despondent
sorrow
suffering

Write a poem about
Joy

glee
rapture
ecstasy
bliss
cheer
contentment
delight
elation

Write a poem about
Rain

Word
Associations

deluge
showers
dew
precipitation
torrent
raindrops
sprinkle
liquid sunshine

Write a poem about
Smiles

grin
laugh
amusement
delight
smirk
beam
dimple
lips

Write a poem about
Music

Word
Associations

melody
hymn
instrumental
orchestra
popular
tune
choral
rhythm

Write a poem about
Travel

trek
ramble
wandering
touring
expedition
tour
voyage
trip

Write a poem about
Fame

Word
Associations

renown
repute
standing
acknowledgement
reputation
popularity
regard
immoral

Write a poem about
Poetry

verse
rhyme
stanza
composition
muse
rhythm
lyric
epic

Write a poem about
Wishes

Word
Associations

intention

aspiration

ambition

hope

longing

will

yearning

desire

Write a poem about
Dreams

fantasy

trance

thought

image

illusion

mental picture

fancy

vision

Write a poem about
Hopes

Word
Associations

expectation
wish
aspiration
ambition
belief
optimism
faith
anticipation

Write a poem about

Parents

guardian
idol
nurture
mother
father
childhood
upbringing
teacher

Write a poem about
Children

Word
Associations

toddler
play
offspring
kids
little
foundling
youngsters
youth

Word Associations

Write a poem about
Fire

smoke

inferno

flame

burn

flare

brimstone

hearth

crackle

Write a poem about
Home

Word
Associations

house
fireside
village
kitchen
hearth
cottage
apartment
tenement

Word Associations

imbibe

taste

chew

eat

digest

masticate

cuisine

diet

Write a poem about
Food

Write a poem about
Time

eternity

hours

period

era

clock

ticktock

infinity

moment

Write a poem about
The Past

memory
distant
history
remembrance
antiquity
memoir
bygone
long ago

Write a poem about
The Future

Word
Associations

destiny

hope

potential

imminent

opportunity

fate

foresee

prophesy

Write a poem about
Science Fiction

space
alien
explore
abduction
invasion
future
humanoid
galaxy

Write a poem about
Truth

Word
Associations

candor
purity
reality
fact
certainty
genuine
honesty
authentic

Word Associations

Write a poem about
Love

adoration

affection

yearning

flame

emotion

ardor

fondness

rapture

Write a poem about
Loneliness

Word
Associations

isolation

empty

quiet

monotony

ache

silence

longing

seclusion

Write a poem about
Anxiety

jittery
dread
uneasy
fretful
disquietude
distress
restless
apprehension

Write a poem about
A Pet

Word
Associations

companion
dog
cat
turtle
rabbit
snake
company
parrot

Word Associations

Write a poem about

Snow

white

drifts

hush

chill

flurry

blizzard

flake

frost

Write a poem about
A River

Word
Associations

flow
course
unstoppable
rushing
waterway
wade
bridge
rapids

Write a poem about
Mountains

peak

summit

climb

valley

slope

ascent

crag

precipice

Write a poem about
A Stranger

Word
Associations

friend or foe
sojourner
mysterious
guest
newcomer
migrant
visitor
acquaintance

Write a poem about
Cowardice

spineless
weak
timid
afraid
abject
pathetic
wimp
deserter

Write a poem about
Brotherhood

comradeship
fraternity
loyal
steadfast
solidarity
partner
unity
fellowship

Write a poem about
A Work of Art

portrait
brushstrokes
texture
color
craft
landscape
shade
light

Write a poem about
The Night Sky

Word
Associations

stars
blackness
moonlight
midnight
pitch
constellations
glimmer
wakeful

Write a poem about
The Moon

crescent
sphere
orb
silver
tide
wane
lunar
Apollo

Write a poem about
The Sun

Word
Associations

golden

effulgence

solstice

radiance

heat

dappled

shadow

zenith

Write a poem about
Imperfection

flaw
uniqueness
foible
blemish
shortcoming
nature
defect
marred

Write a poem about
Chance

luck
fortune
random
fate
remote
providence
gamble
destiny

Write a poem about
Serendipity

karma
kismet
circumstance
divine
fluke
break
happenstance
unexpected

Write a poem about
Change

shift
transition
metamorphosis
revision
season
switch
transmutation
variance

Word Associations

lips
cheek
warm
wet
clasp
passion
caress
embrace

Write a poem about
Kisses

Write a poem about
Temptation

Word Associations

covet

allure

bait

enticing

tantalize

draw

seduction

irresistible

Word Associations

right
code
moral
truth
fair
redress
recompense
rule

Write a poem about
Justice

Write a poem about
Inequality

Word
Associations

unfair
injustice
racism
difference
bias
disparity
privilege
misfortune

Word Associations

Write a poem about
Freedom

independence
autonomy
opportunity
liberation
range
ability
laissez faire
indulgence

Write a poem about
A Waterfall

Word
Associations

cascade

power

possibility

rapids

spray

foam

roaring

pool

Write a poem about
Creativity

inventive
originality
talent
vision
clever
imagination
genius
inspiration

Write a poem about
Gratitude

grace
profound
praise
recognition
thankful
honor
debt
humility

Write a poem about
Faith

adoration

certainty

trust

fealty

belief

conviction

confidence

dogma

Write a poem about
Violence

Word
Associations

harm
brutality
aggression
pain
injury
attack
assault
tumult

Word Associations

Write a poem about
Tragedy

doom

adversity

death

wreck

catastrophe

affliction

misfortune

curse

Write a poem about
Summer

Word
Associations

sunshine
heat
beach
vacation
sweat
sultry
dog days
seaside

Word
Associations

Write a poem about
Winter

snow
chill
solstice
igloo
yule
fireside
evergreen
arctic

Write a poem about
Fall

Word
Associations

autumn

orange

foliage

harvest

leaves

branches

cornucopia

death

Word Associations

God
otherworldly
worship
creed
principle
faith
teachings
passion

Write a poem about
Spirituality

Write a poem about
Warmth

Word
Associations

comfort
tenderness
sharing
closeness
reassurance
glow
affection
radiate

Write a poem about
Scared

aghast
stricken
fearful
danger
risk
unsure
panic
afraid

Write a poem about
Tradition

values

custom

heritage

legend

fable

culture

folklore

convention

Write a poem about
A Glance

brief

impression

fleeting

shy

blink

eye contact

peek

flash

Write a poem about
Grief

bereaved
loss
sorrow
tears
lament
anguish
heartache
woe

Write a poem about
Beauty

behold
brilliance
lovely
pathos
muse
elegance
striking
exquisite

Write a poem about
Wonder

Word
Associations

awe
marvel
curiosity
jolt
reverence
admiration
perplexity
fascination

Word Associations

crush
itch
amore
devotion
caring
warmth
tingle
tender

Write a poem about
Affection

Write a poem about
Bliss

Word
Associations

joy
euphoria
paradise
rapture
glory
nirvana
ecstasy
completeness

Write a poem about
Broken Heart

stricken

heartsick

pain

doleful

betrayal

vulnerable

crushed

regret

Write a poem about
Intelligence

Word
Associations

insight

literate

shrewd

brains

discern

mind

brilliance

sense

Word
Associations

Write a poem about
A Bird in Flight

freedom
soar
glide
voyage
wing
perspective
omen
breeze

Write a poem about
Pride

Word
Associations

lion
dignity
pomp
ostentation
arrogance
boast
confidence
ego

Write a poem about
Weakness

debility

frailty

lack

folly

vice

shortcoming

feeble

vulnerability

Write a poem about

Health

Word
Associations

fortitude
fettle
form
tone
vigor
potency
robust
hardy

Word Associations

esteem

brashness

assurance

morale

poise

tenacity

conviction

dignity

Write a poem about
Confidence

Write a poem about
Marriage

Word
Associations

couple
alliance
love
wedlock
matrimony
mate
courtship
pledge

Write a poem about
Possibilities

potential
limitless
foresight
promise
action
hazard
plausible
shot

Write a poem about
Virtue

Word
Associations

paragon
merit
ethical
righteous
purity
charity
worthy
upright

Write a poem about
Maturity

experience
adult
sophistication
wisdom
prime
ripe
advanced
apt

Write a poem about
Treasure

trove
precious
rare
wealth
value
abundance
fortune
cache

Word Associations

stock
sure
credence
conviction
loyal
integrity
charge
steadfast

Write a poem about
Trust

Write a poem about
Compassion

Word
Associations

benevolence

meek

tenderness

empathy

heart

clemency

mercy

softness

Word Associations

cosmos
creation
infinite
totality
relativity
immense
vast
space

Write a poem about
The Universe

Write a poem about
A Fragrance

bouquet

balm

aroma

savory

musk

honeysuckle

intoxicate

subtle

Write a poem about
Meditation

rumination
reflection
peace
introspection
tranquil
rapt
Zen
ponder

Write a poem about
Independence

freedom
sovereign
self-reliance
autonomy
strength
confidence
assuredness
determination

Write a poem about
Challenges

odds

trials

dare

gauntlet

moxie

overcome

persevere

obstacle

Write a poem about
Patience

Word
Associations

stoic

serene

calm

peace

composure

humility

gentleness

placid

Word Associations

viewpoint

context

scene

vista

shift

frame

broad

angle

Write a poem about
Perspective

Write a poem about
A Voyage

Word
Associations

passage
jaunt
journey
crossing
discovery
vessel
explore
search

Write a poem about
Moments

occasion
flash
instant
present
pause
savor
twinkling
linger

Write a poem about
Expectations

Word
Associations

promise

notion

supposition

design

motive

prospects

hope

potential

Write a poem about
Blessings

gifts
grace
thanks
benediction
luck
boon
bestow
bounty

Write a poem about
Values

Word
Associations

mores
scruples
ethics
standards
conscience
ideals
code
tenet

Word Associations

Write a poem about

Laughter

joy
belly
medicine
shriek
howl
merriment
rejoice
burst

Write a poem about
Silence

hush
lull
peace
calm
quietude
stillness
whisper
profound

Word
Associations

Write a poem about
Insecurity

doubt
hesitancy
uncertainty
struggle
fear
exposed
misgiving
caution

Write a poem about
Solitude

Word
Associations

alone
isolation
seclusion
recluse
introvert
private
remote
hermit

Word
Associations

Write a poem about
Eternity

infinity
everlasting
perpetual
endless
future
immortality
eon
lasting

Write a poem about
Romance

Word
Associations

thrill

amour

affair

flirtation

entangle

intimacy

passion

desire

Write a poem about
Adventure

enterprise
exploit
undertaking
escapade
climb
dare
gamble
voyage

Write a poem about
Angels

Word
Associations

guardian

ascend

ethereal

heavenly

spirit

cherub

seraph

being

Word Associations

gratitude
tribute
thankful
salute
favor
regard
esteem
veneration

Write a poem about
Appreciation

Write a poem about
Carpe Diem

Word
Associations

live

pluck

seize

dare

boldness

endeavor

audacity

nerve

Write a poem about
Colors

pigment
shade
tincture
complexion
scarlet
cobalt
brilliance
vermillion

Write a poem about
Conflict

Word
Associations

fray
breach
clash
rival
contest
embroil
protagonist
strife

Word Associations

prowess

spunk

intrepidity

fortitude

lion-hearted

dauntless

guts

pluck

Write a poem about
Courage

Write a poem about

Devotion

piety
loyalty
fidelity
earnest
sanctity
fealty
deference
service

Write a poem about

Family

kin

lineage

clan

tribe

blood

kindred

relationships

generation

Write a poem about
Forgiveness

Word
Associations

clemency
compassion
mercy
absolution
lenience
charity
grace
repent

Word Associations

pact
brotherhood
sisterhood
league
alliance
bond
rapport
camaraderie

Write a poem about
Friendship

Write a poem about
Growth

Word
Associations

surge
prosper
flowering
sprout
swell
unfold
boost
bud

Write a poem about
Hate

ire

venom

spite

scorn

malevolence

aversion

bile

wrath

Write a poem about
Humanity

people
mankind
good will
fellowship
civility
uprightness
forbearance
compassion

Word Associations

reserve
bashfulness
docile
meek
fawn
modesty
contrition
gentle

Write a poem about
Humility

Write a poem about
Imagination

Word
Associations

vivid
invention
fantastic
stimulating
vision
enterprise
originality
artistry

Write a poem about
Innocence

virtue

clean

lamb

impeccable

artless

modesty

decency

temperance

Write a poem about
Inspiration

Word
Associations

whimsy
insight
elation
fervor
delight
talent
fancy
revelation

Write a poem about
A Journey

pilgrimage
sojourn
roam
traverse
odyssey
expedition
circumnavigation
wander

Write a poem about
Longing

craving

entreaty

throb

lovesick

thirst

pining

hope

languish

Write a poem about
Moving On

hasten

momentum

go forth

launch

progress

proceed

continue

push

Write a poem about
A Mystery

conundrum
pickle
quandary
crux
enigma
puzzlement
charade
baffle

Write a poem about
Paradise

eden
Elysium
heaven
bliss
delight
utopia
transport
nirvana

Write a poem about
Passion

ardor

fervor

intensity

heat

zest

lust

desire

zeal

Word Associations

order
truce
unity
amity
quiet
harmony
tranquility
joy

Write a poem about

Peace

Write a poem about
Sleep

Word
Associations

dream
doze
Morpheus
repose
torpor
trance
slumber
somnolence

Word Associations

partner
lover
spouse
kindred
confidante
companion
true love
sweetheart

Write a poem about
Soul Mate

Write a poem about
Strength

Word
Associations

vitality
fortitude
health
power
muscle
sinew
pith
potency

Write a poem about
A Sunset

eventide
gloaming
nightfall
dusk
orange
gold
decline
twilight

Write a poem about
Visions

Word
Associations

perception
glimpse
insight
acumen
brilliance
fancies
musings
imagination

Write a poem about
Nighttime

sleepless
moonless
darkness
wakeful
vigil
dim
shadow
black

Write a poem about
Growing Older

golden years
mature
dotage
decline
elder
venerable
evolved
perfected

Write a poem about
A Choice

marriage
path
challenge
alternative
dilemma
passion vs. logic
popular
ballot

Write a poem about
Jealousy

Word
Associations

rivalry
envy
antagonism
animosity
spite
grudge
covetous
strife

Write a poem about
Betrayal

duplicity

perfidy

Judas

Brutus

trickster

double

heartbreak

treason

Write a poem about
Society

Word
Associations

trend

media

opinion

populism

fashion

responsibility

outcast

progress

Write a poem about
Forgetting

oblivion

disremember

consign

escape

pass

omit

scorn

clean slate

Write a poem about
Luck

stroke
profit
win
windfall
break
avail
odds
fortune

Write a poem about
Regret

penitence
self-reproach
repine
bitterness
lament
bemoan
rue
defeat

Write a poem about
Mother

matriarch
origins
childhood
warm
womb
complex
goddess
caregiver

Word Associations

Write a poem about

Insanity

delirium

lunacy

mania

irrational

incoherent

delusion

neurosis

folly

Write a poem about
A Secret

Word
Associations

cryptic
dark
hush
private
clouded
mist
regret
buried

Write a poem about
A Surprise

sudden

exclaim

unexpected

epiphany

godsend

ambush

astound

baffle

Write a poem about
Dilemma

Word
Associations

bind
choice
boxed in
impasse
scrape
plight
mess
quagmire

Word
Associations

Write a poem about
A Voice

murmur

whisper

holler

soft

husky

sultry

conscience

instinct

Write a poem about
Perfection

flawless

supreme

paragon

diamond

pure

ideal

sublime

unattainable

Write a poem about
A Shadow

two-faced

dark side

lightless

mimic

obfuscate

blacken

obscure

extinguish